Fifty-Eight

Plantae

(Plants)

Mila Fox

Fifty-Eight

Plantae

(Plants)

By Mila Fox

Illustrated by Mila Fox

Copyright © 2018 by Mila Fox

All Rights Reserved.

10 9 8 7 6 5 4 3 2

Meant 2 Bea Publications

Providence, Rhode Island

MORE BY THIS AUTHOR

Bare to the Bones: Charcoal Figure Art

Beautiful, Be-YOU-tiful, Be YOU

Be-YOU-tiful Crusade: Lend a Hand

Be-YOU-tiful Crusade: Don't Be Afraid

Be-YOU-tiful Crusade: Bullying Can Happen At Any Age

Be-YOU-tiful Crusade: Siblings Day

CHIC-ipedia

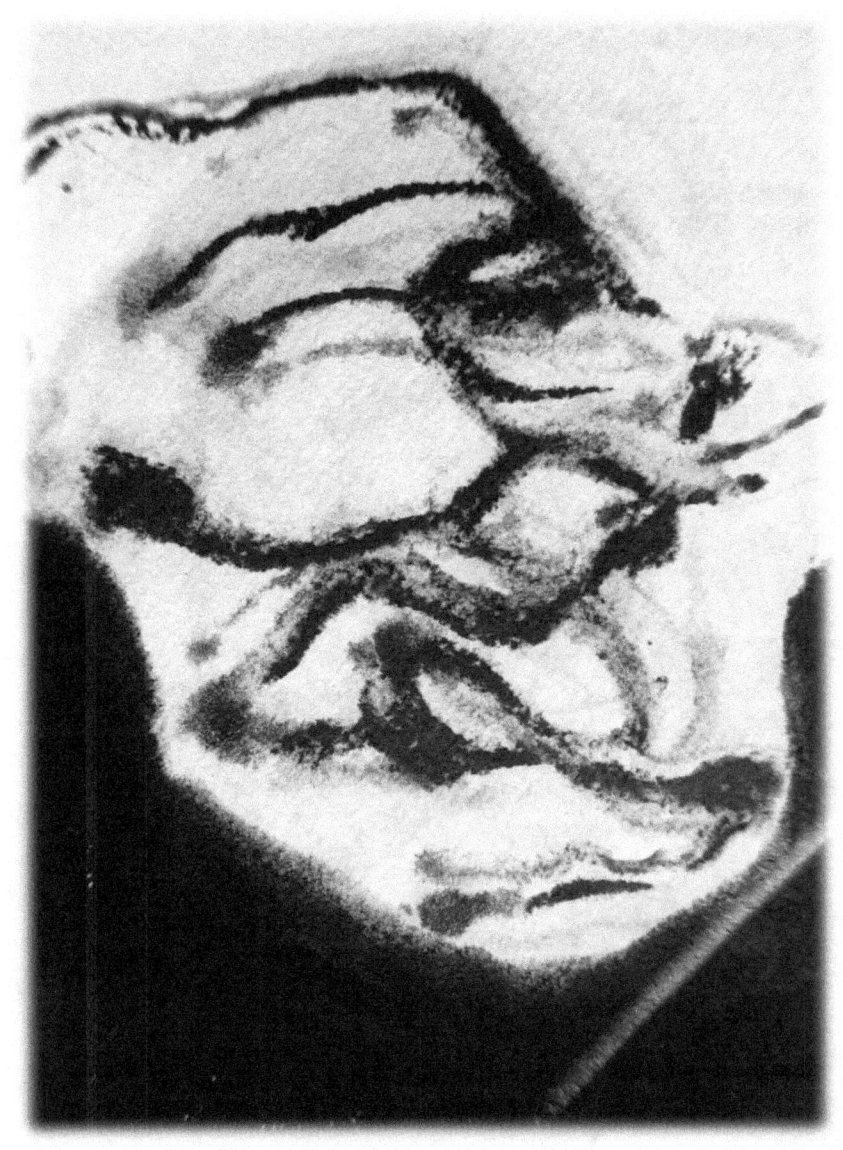

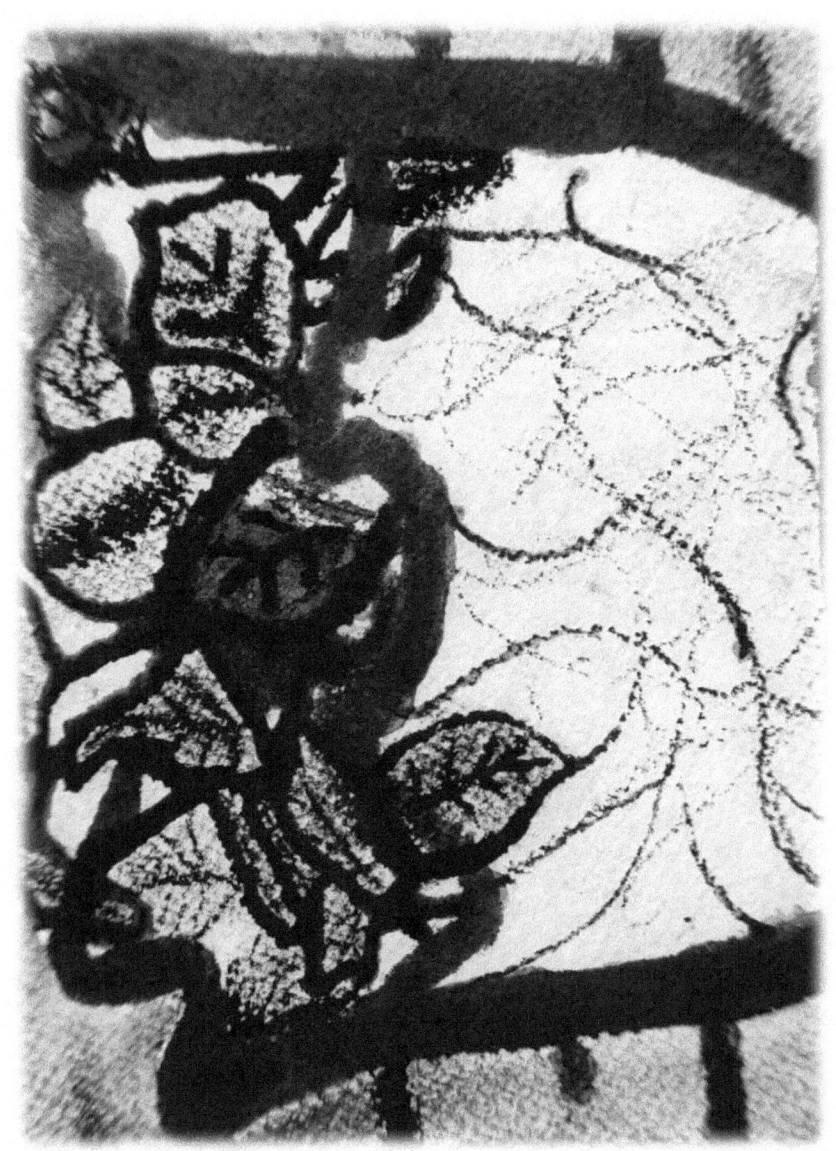

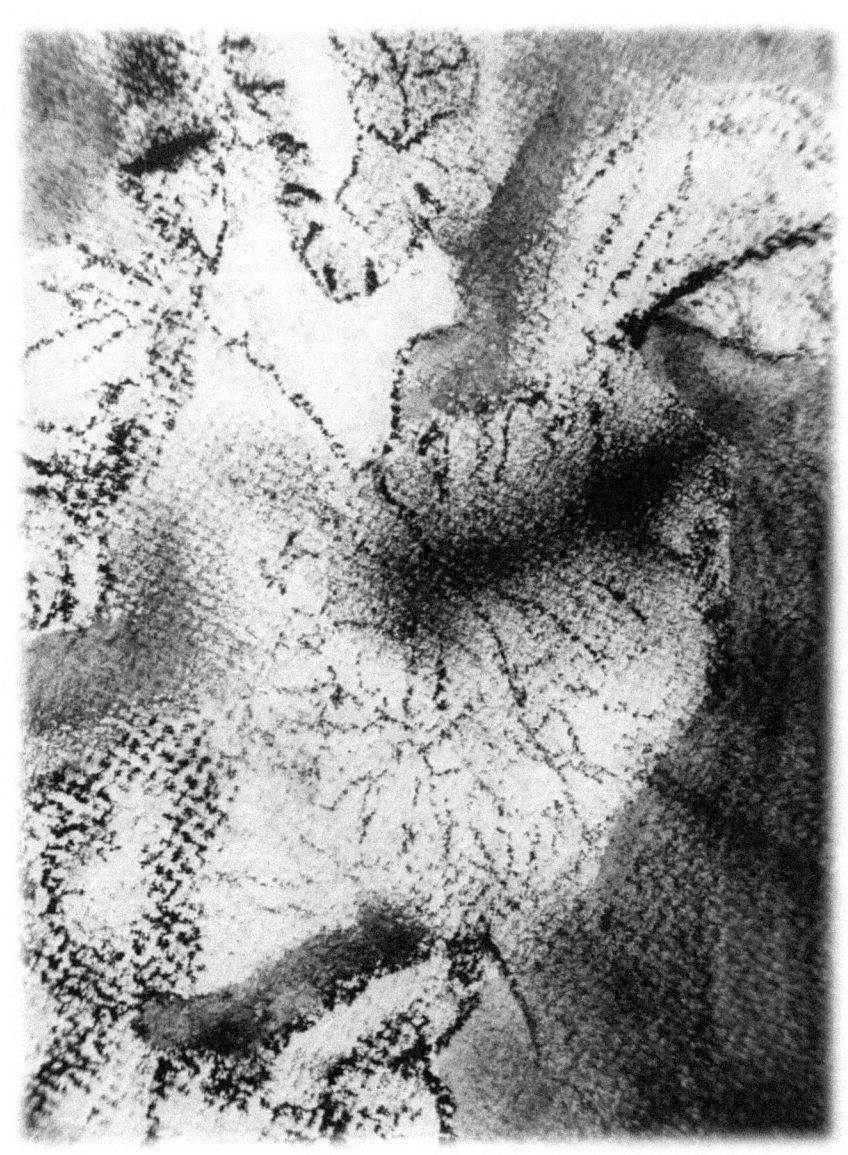

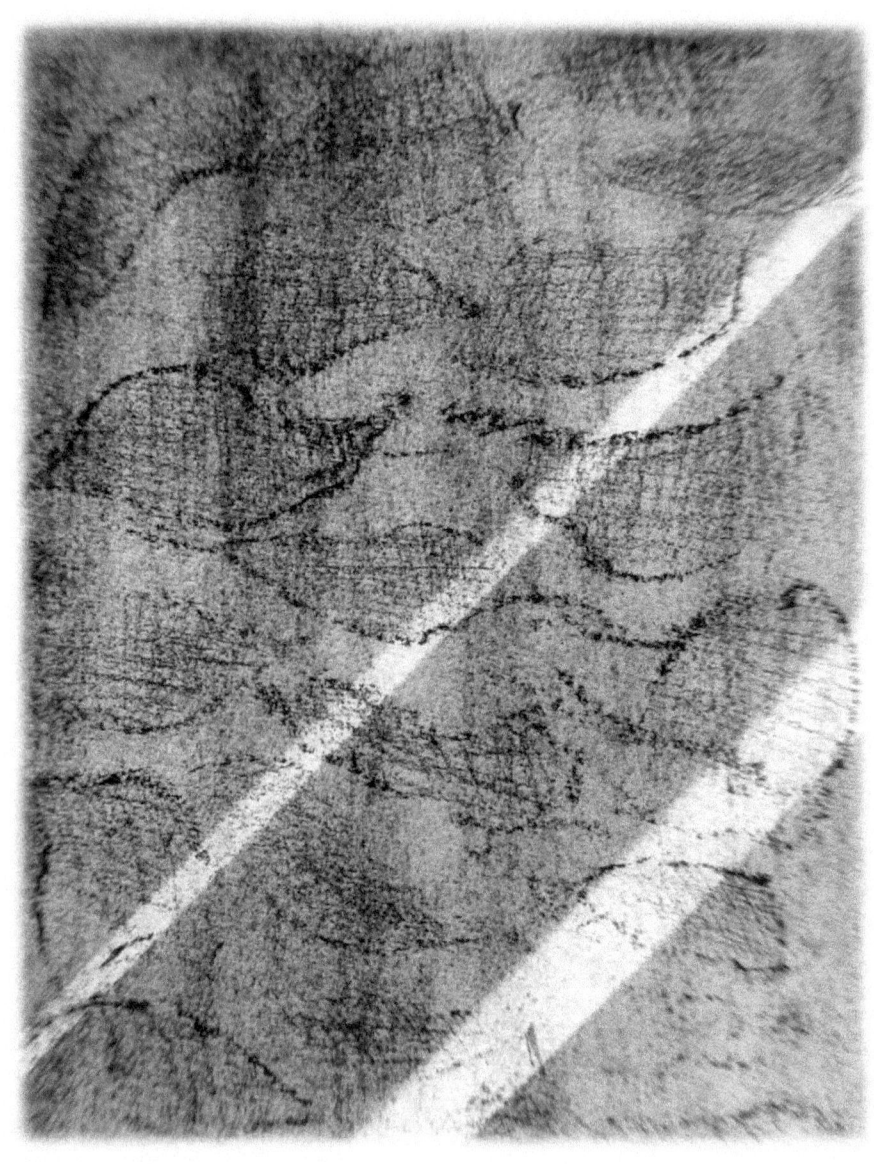

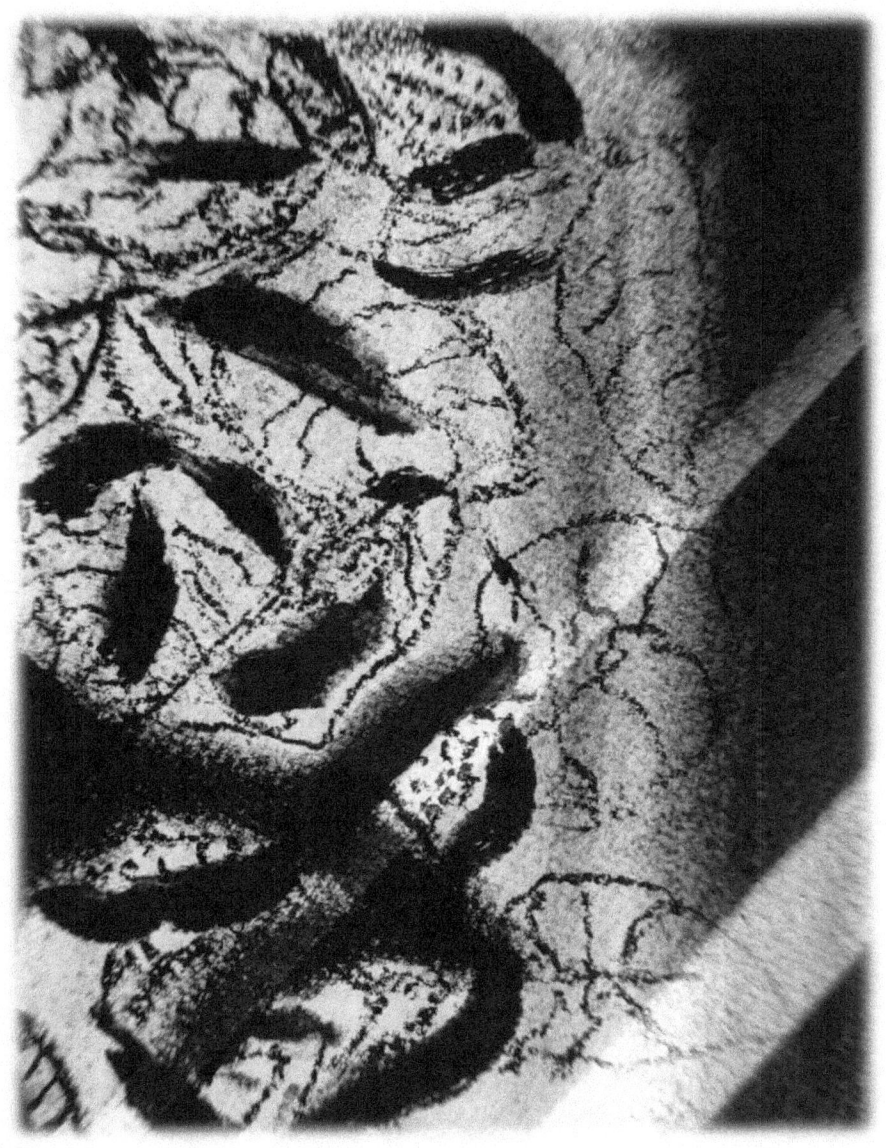

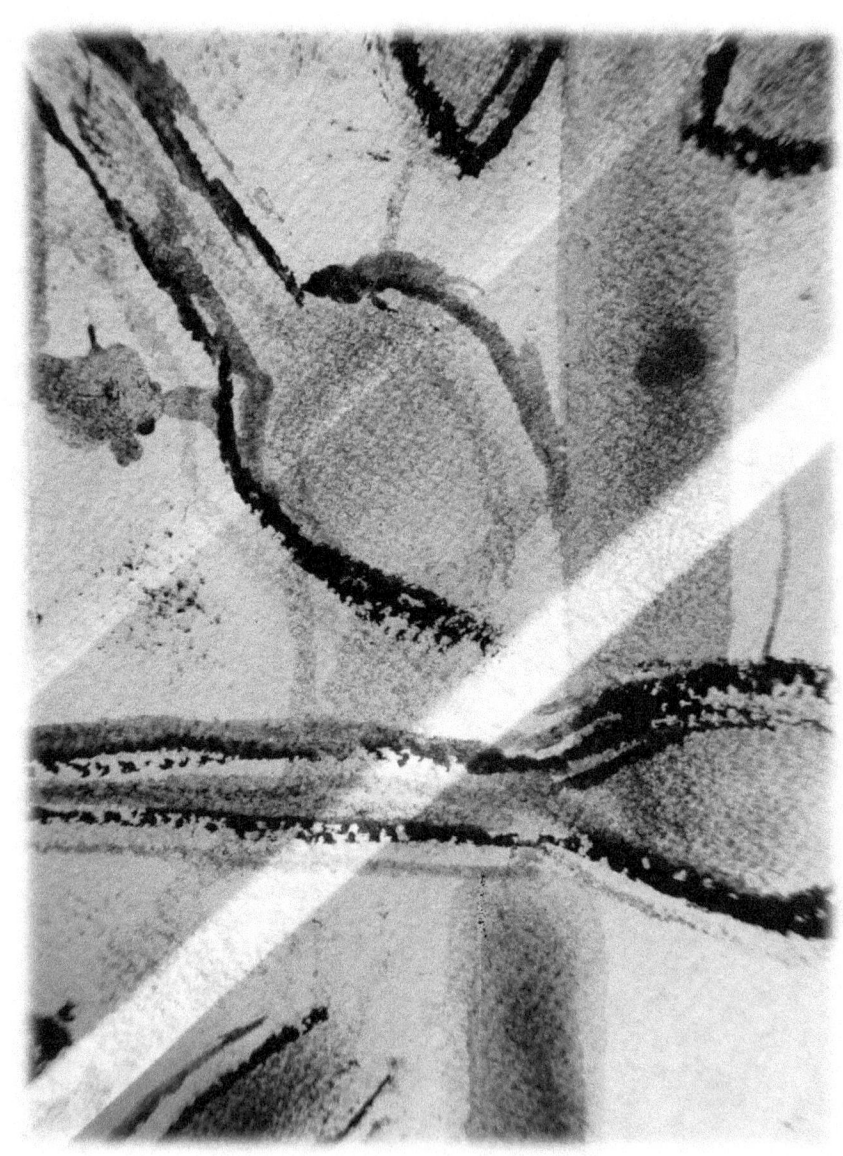

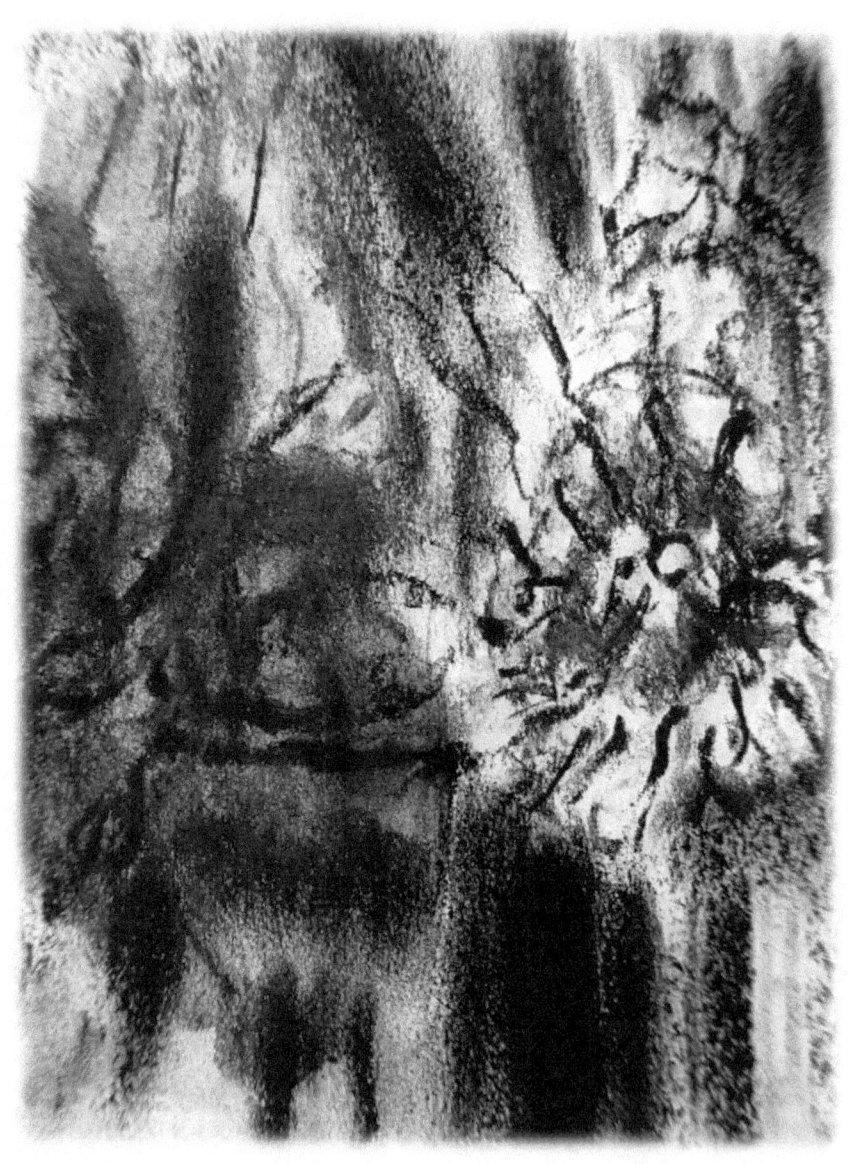

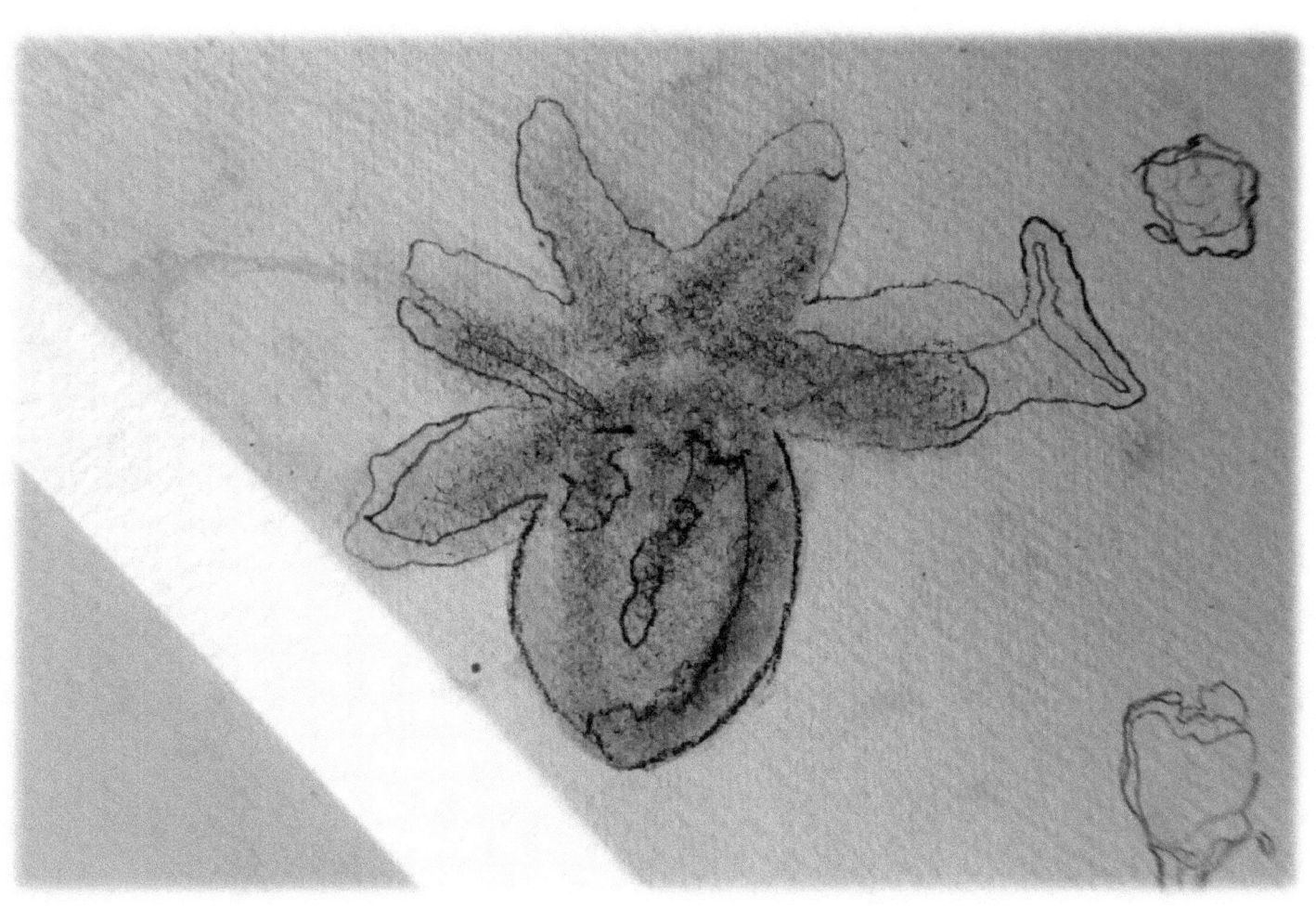

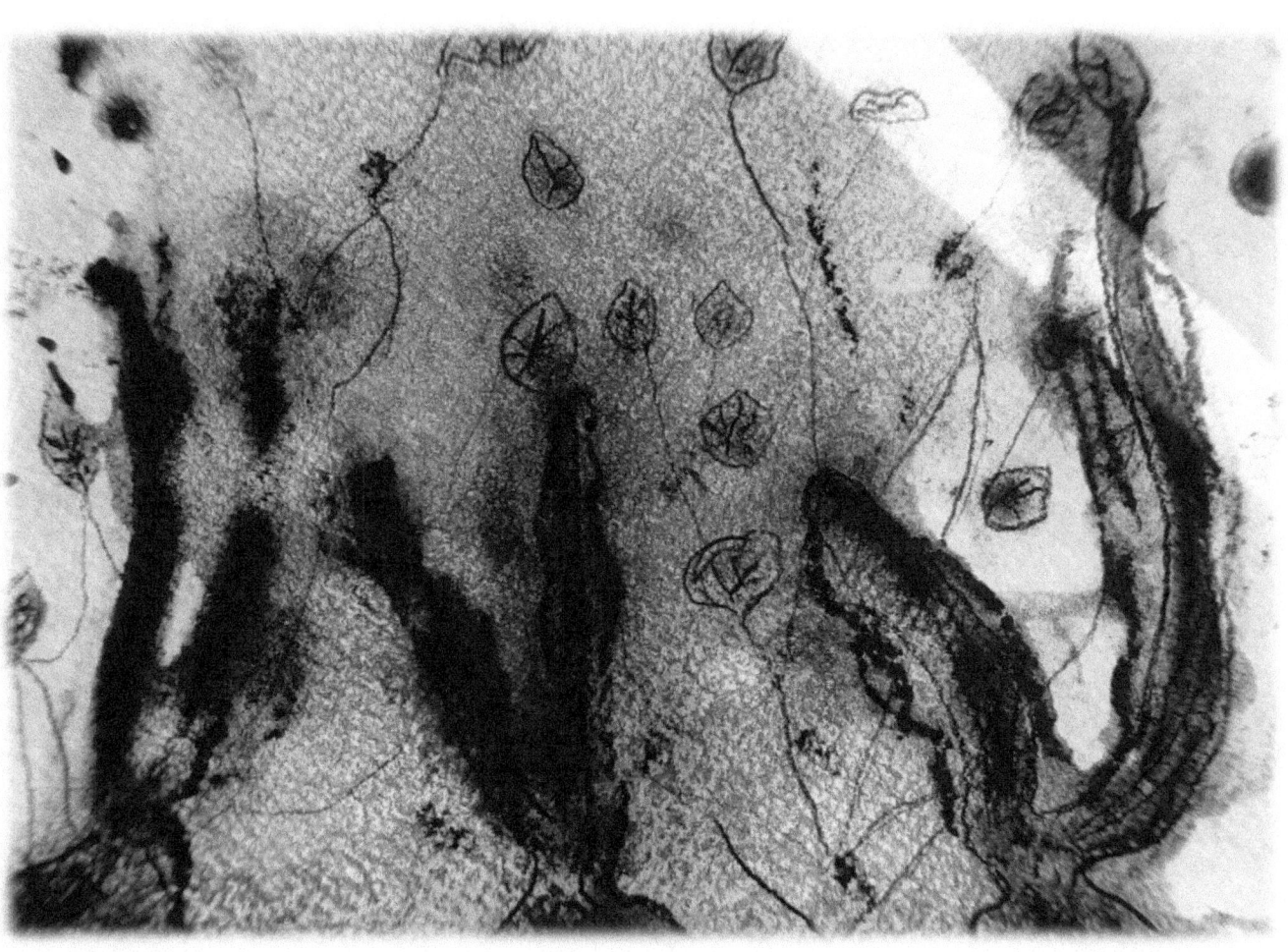

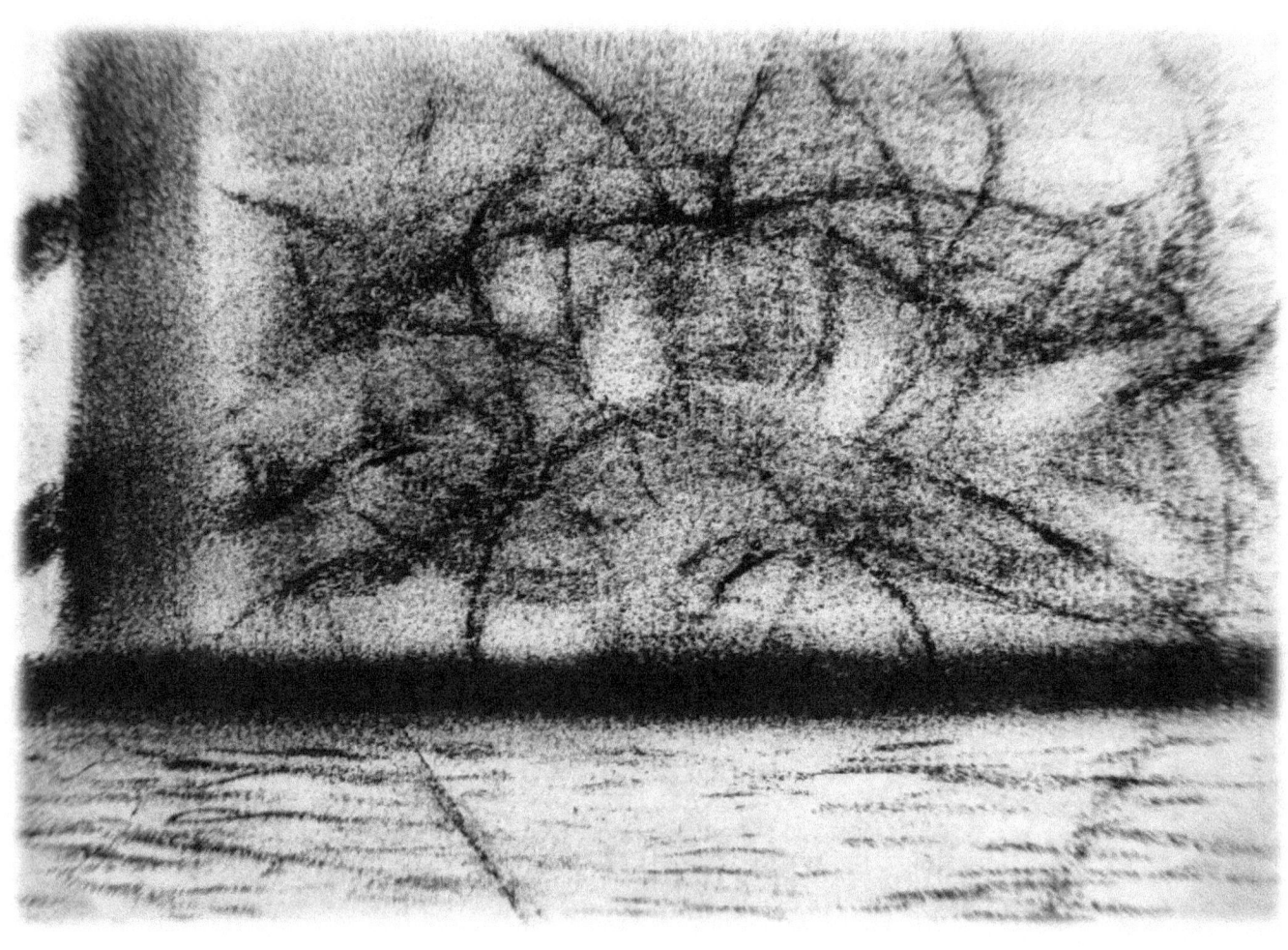

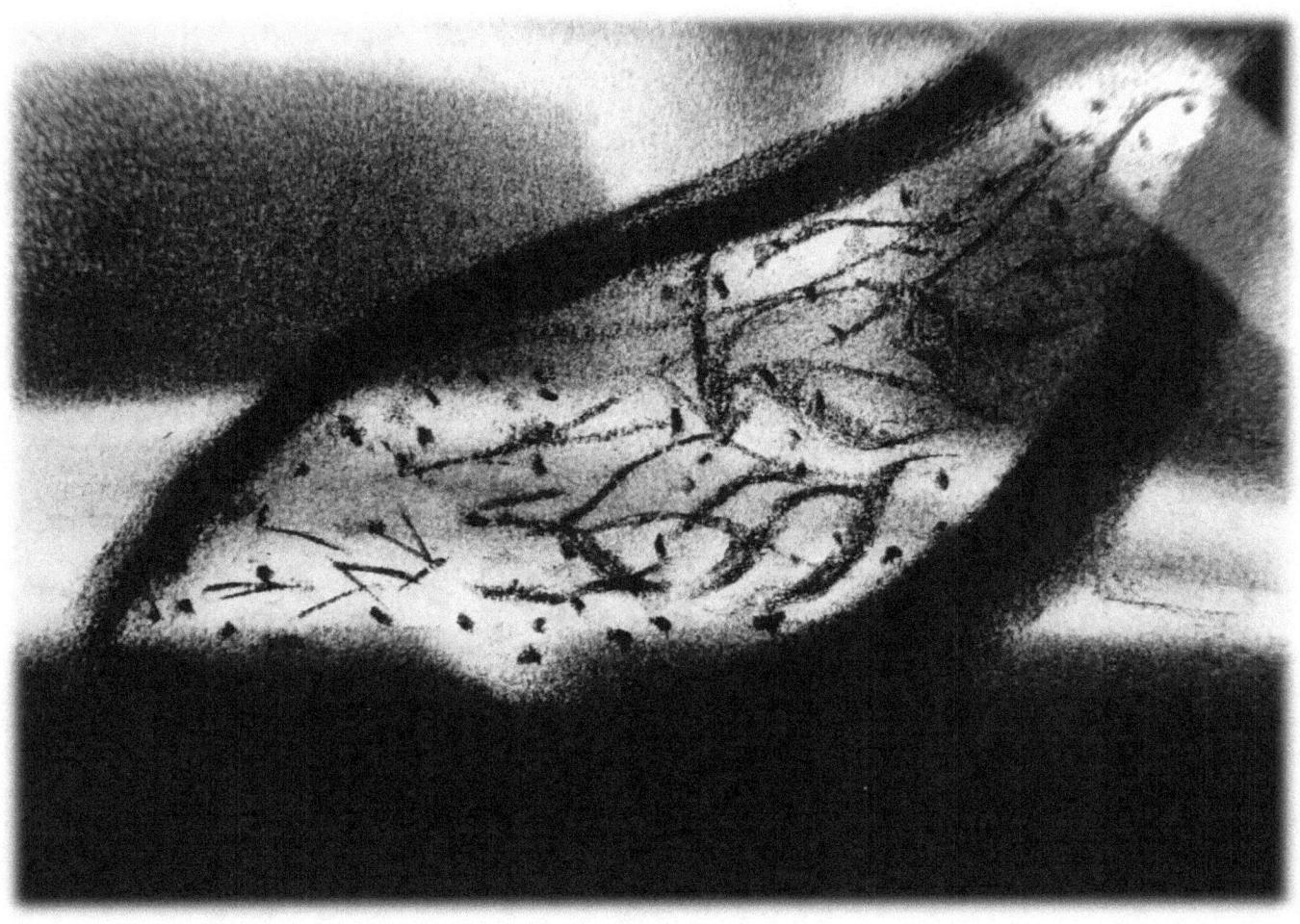

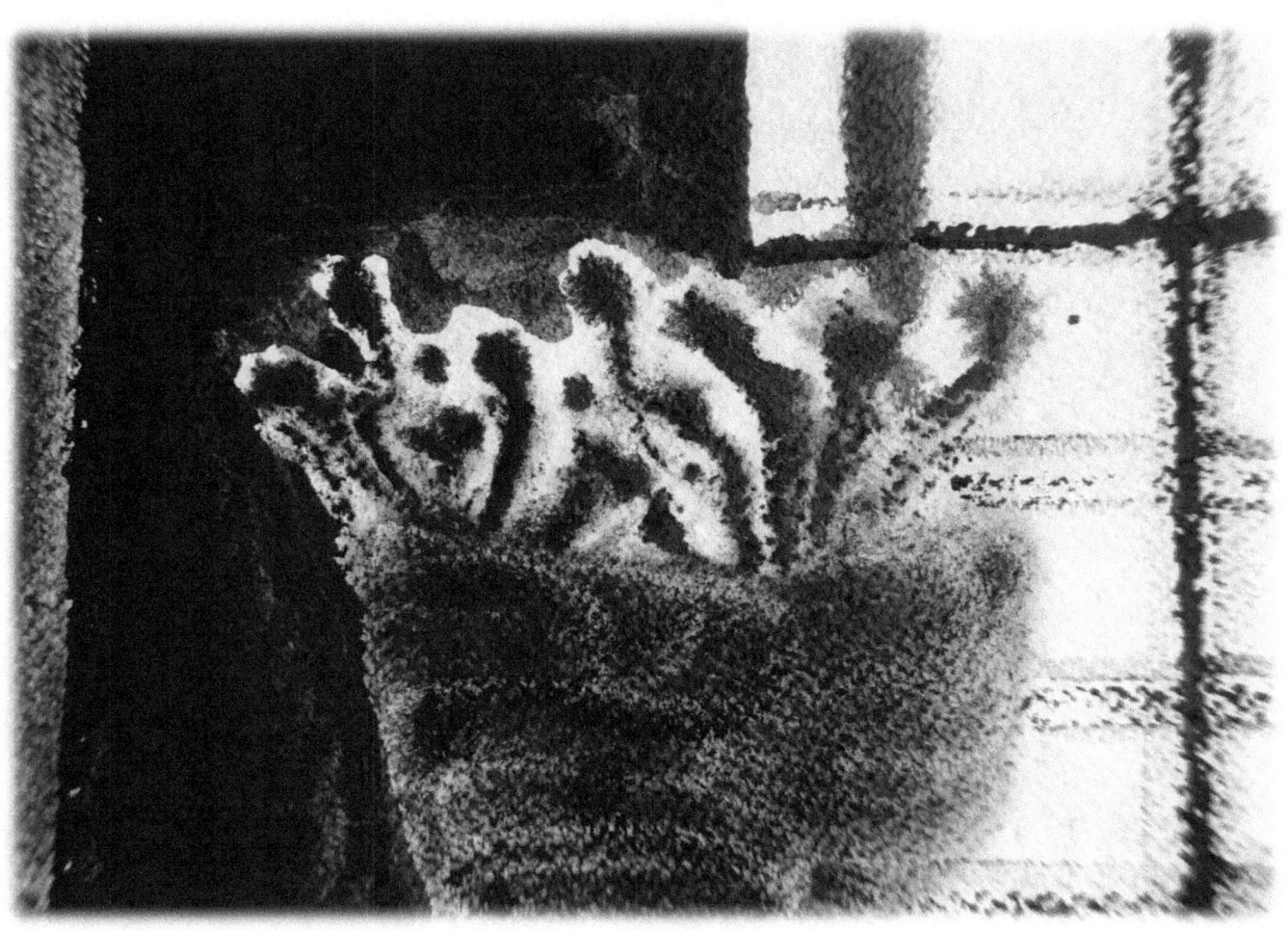

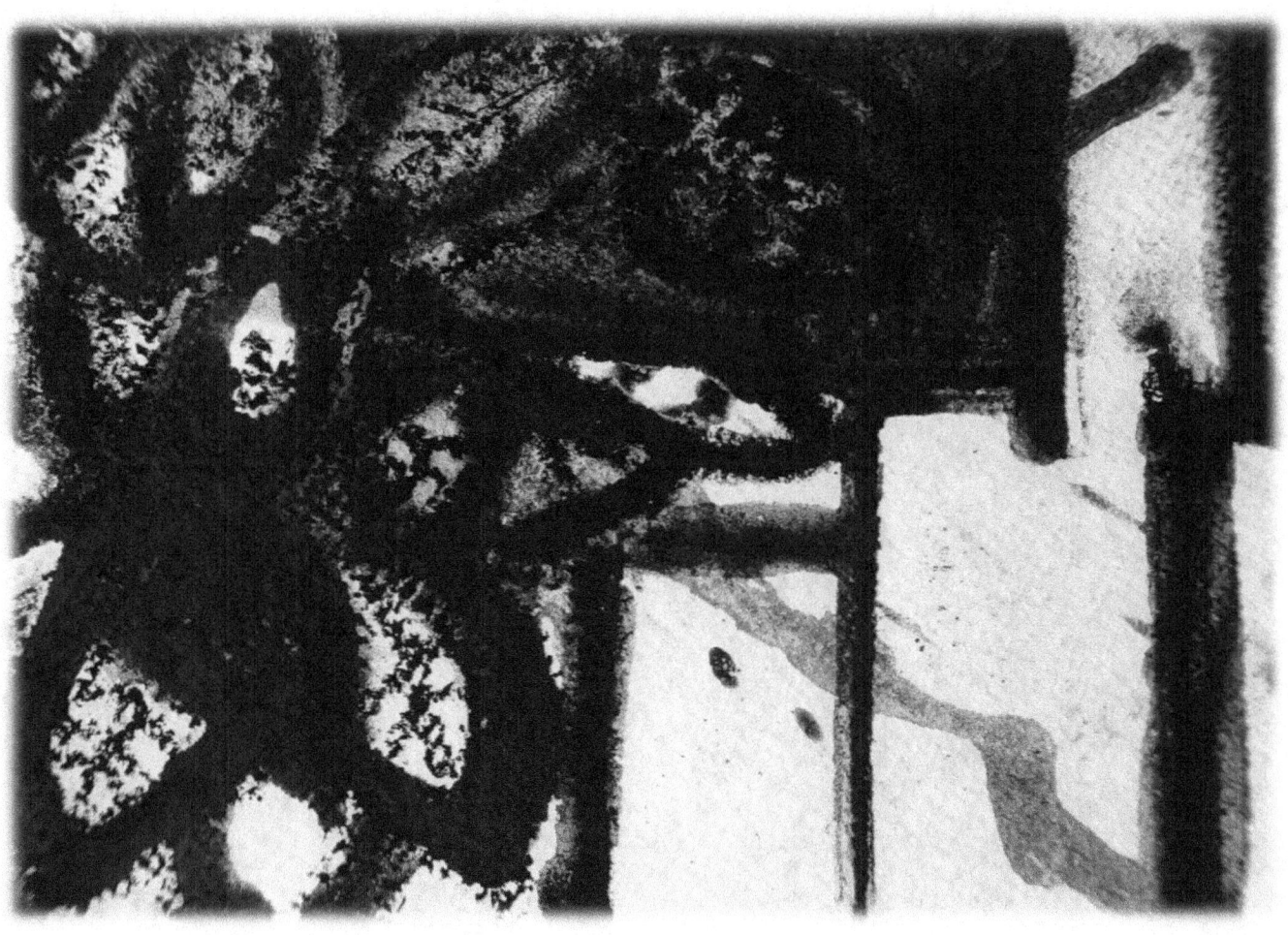

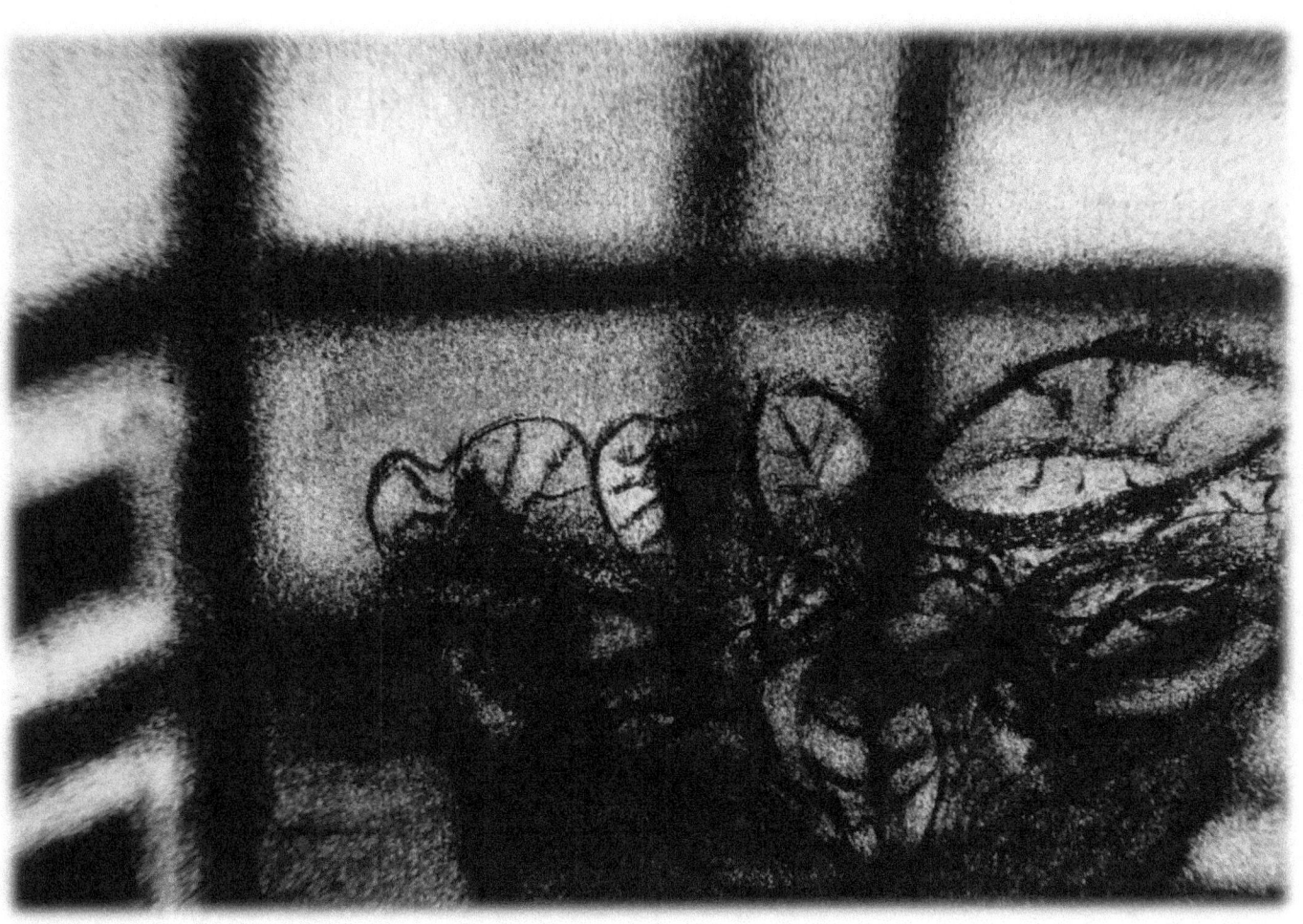

About the Author

MILA FOX is an actress, model, photographer, and author. In addition to acting, running her fashion blog, CHIC-ipedia, and Mila Fox Photography, Mila is an advocate for Autism Awareness and Anti-Bullying.

www.ingramcontent.com/pod-product-compliance
Lightning Source LLC
Chambersburg PA
CBHW081016170526
45158CB00010B/3064